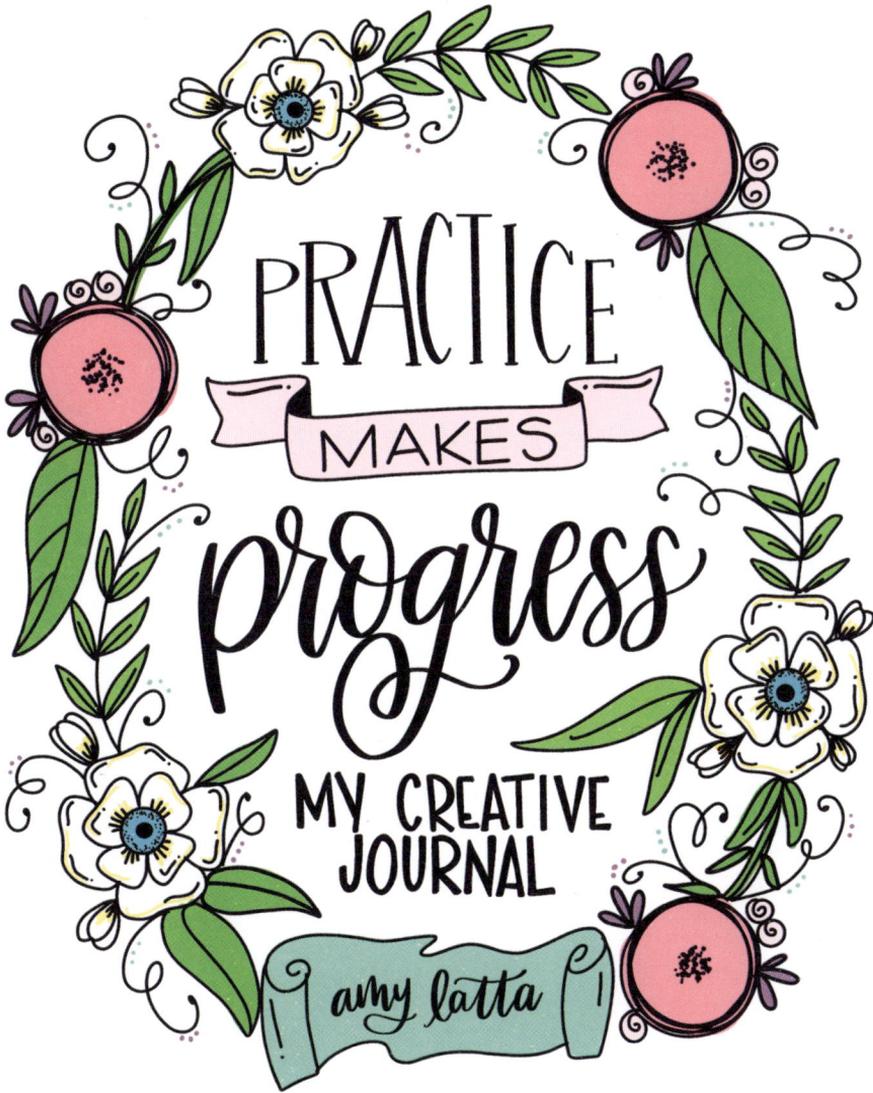

PRACTICE

MAKES

progress

MY CREATIVE JOURNAL

amy latta

PAGE STREET
PUBLISHING CO.

PAGE STREET
PUBLISHING CO.

Copyright © 2021 Amy Latta

First published in 2021 by
Page Street Publishing Co.
27 Congress Street, Suite 105
Salem, MA 01970
www.pagestreetpublishing.com

Distributed by Macmillan, sales in Canada by The Canadian Manda Group.

25 24 23 22 21 1 2 3 4 5

ISBN-13: 978-1-64567-368-2
ISBN-10: 1-64567-368-5

Library of Congress Control Number: 2021931389

Cover and book illustrations by Amy Latta
Book design by Laura Benton for Page Street Publishing Co.

Printed and bound in China

For Sarah Hodsdon.

You helped me put words to my life's mission of helping others to discover and express their creativity. I can never thank you enough. To the moon and back.

Contents

Introduction

Hello, friend!

Let me introduce myself. My name is Amy, and I love to create! Throughout my adult life, I have been a teacher, a professional dancer, an artist, an author and a business owner. What I love most is making beautiful things and teaching others to do the same. I have tutorials for all kinds of art and craft projects on my website, amylattacreations.com, and I do regular craft segments on television in the hopes of inspiring viewers to try them at home. Additionally, I teach local and national workshops and have written five books about the art of hand lettering. I feel incredibly lucky and blessed to be able to make a living doing what I'm passionate about: inspiring creativity. But that's enough about me. Let's talk about you!

The fact that this journal has made its way into your hands tells me something exciting: You are ready to take a creative journey. Whether you consider yourself naturally artistic or the furthest thing from it, you are willing to join me as we discover, embrace and express creativity in a variety of forms throughout these pages.

This journal is designed to give you specific questions and exercises to get you working those creative muscles, as well as to give you the freedom to express yourself in whatever ways you enjoy most. You'll have opportunities to write, to doodle, to reflect, to make plans and even to create larger works of art. There are no right or wrong answers, and what you do with these exercises is entirely up to you! My hope is that as we explore 25 quotes about art and creativity, you'll be stretched, challenged and inspired. I hope you'll discover new things, and most of all, that you'll have so much fun along the way.

This journal belongs to you, so mark it up and make it your own. Cut out some of the pages to use, display or give away. In fact, some of the exercises will specifically ask you to do just that. Don't worry about making everything neat or perfect; this is a place for exploration and expression, not perfection. If any of my hand-lettered illustrations inspire you, feel free to cut those out and display them, too, or re-create them yourself.

I don't know about you, but I can't wait to get started. Grab a few markers, a pencil and a good eraser, and let's begin this creative journey together!

inspiration COMES DURING WORK, NOT *before it.*

— MADELEINE L'ENGLE

Finding Your Inspiration

One of the roadblocks we can face on our creative journey is the idea that we have to wait until we've got a great idea before we start working. The reality is that creativity rarely works that way. It's only after we pull out our supplies and begin the process that our project will start to take shape. As we get our hands covered in paint or clay or glitter, or we start putting words on a page, the ideas will roll in and we'll become inspired. The more we experiment, the better an idea we'll have of what works and what doesn't. Don't wait around for inspiration—get busy and make it happen! Which supplies do you have on hand that you could grab right now?

The Ghost of Inspiration Past

What's your favorite thing that you've ever created? What made it so special? Think about what inspired you to make it. Was it for someone else? Was it for an occasion? Was it something you knew you always wanted to do, or did it surprise you?

Inspiration Is Everywhere

Inspiration is rarely like a lightning bolt from the sky; instead, it's all around us. Take the next few minutes to concentrate on your senses one by one and jot down things that grab your attention. Then, once you finish, choose whichever inspired you most and use it as a springboard for a creative work!

The SIGHT of:_____

The SOUND of:_____

The SMELL of:_____

The TASTE of:_____

The TOUCH of:_____

Just Get Started!

The best way to get inspired is to dive right in! So what are you waiting for? The next page is a blank slate where you can create any kind of masterpiece you like. Feel free to draw, paint, hand letter . . . whatever your heart desires. Write a poem, brainstorm the plot of a short story or draw plans for something you want to build, bake or sculpt. Don't overthink it, just start creating and get inspired as you go. Color the border, too. Use this art to remind you not to wait for the perfect idea before you begin your next project!

Creativity takes Courage

Henri Matisse

Creativity Takes Courage

Despite what some folks think, living a creative life doesn't mean everything is always rainbows and flowers. In fact, it can be a real challenge that's sometimes downright scary. Every time you create, you're taking a risk. You're putting a part of your soul out there into the universe where it could potentially face criticism or rejection. That is no small feat! It requires real courage to step out and try something new, in spite of not knowing how it will turn out or what others may think. But imagine how much less beautiful the world would be if artists and creators let fear get in the way of their next creation! Don't be afraid to step out and create what only you can make.

Is courage something you have thought of as part of the creative process before?

The Voices in My Head

When you have a new idea, what fears pop up in your mind? What do the voices in your head tell you that cause you to hesitate instead of starting your project and making it happen? Fill in each thought bubble with some of the doubts that hold you back.

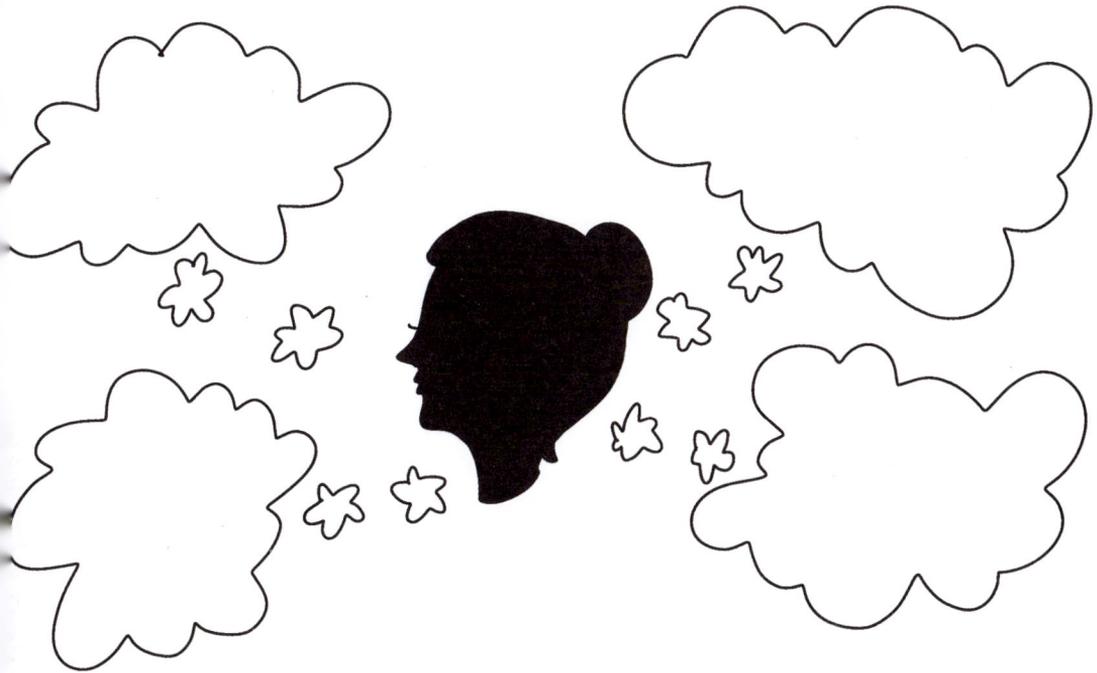

Fighting Back

More often than not, our doubts and fears are totally unfounded! Our "worst case scenario" would never really happen, and the things that hold us back are actually keeping us from all the things we could achieve. It's time to fight back! For each doubt you wrote in a thought bubble on the previous page, come up with a bold response to write in the boxing gloves below. For example, if you thought, "Someone might laugh at my work," you can fight back by saying, "Everyone has different tastes," or "The people who care about me will support me."

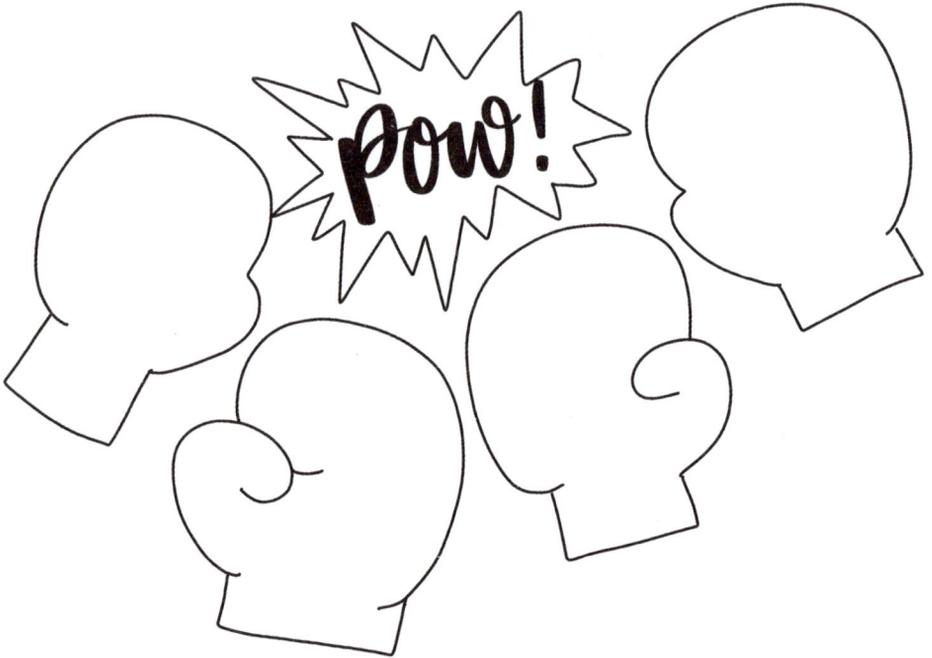

Summoning Your Courage

What is the bravest thing you've ever done? Maybe it was parasailing over the ocean. Perhaps it was trusting another person, starting a family or accepting a new job. Maybe you reached out to someone with a big idea. What was it that motivated you and gave you the courage to take that leap? Write about or illustrate that experience in the space below. Then, let it inspire you to find that same boldness in your next creative endeavor.

If I Knew
I Couldn't Fail . . .

What is it that would take the most courage in your creative journey right now? Is there a new skill you want to learn? A certain project you want to create? Something you want to share with someone or a way you'd like to reach a bigger audience? Write that goal twice on the next page (once in each box). Then, cut out the page and cut it in half. Hang one half wherever you do your creative work to remind you of your goal. Then, give the other half to someone you trust so they can hold you accountable. Tell them that you have something you'd like to do and ask them to remind you along the way to have the courage that creativity requires!

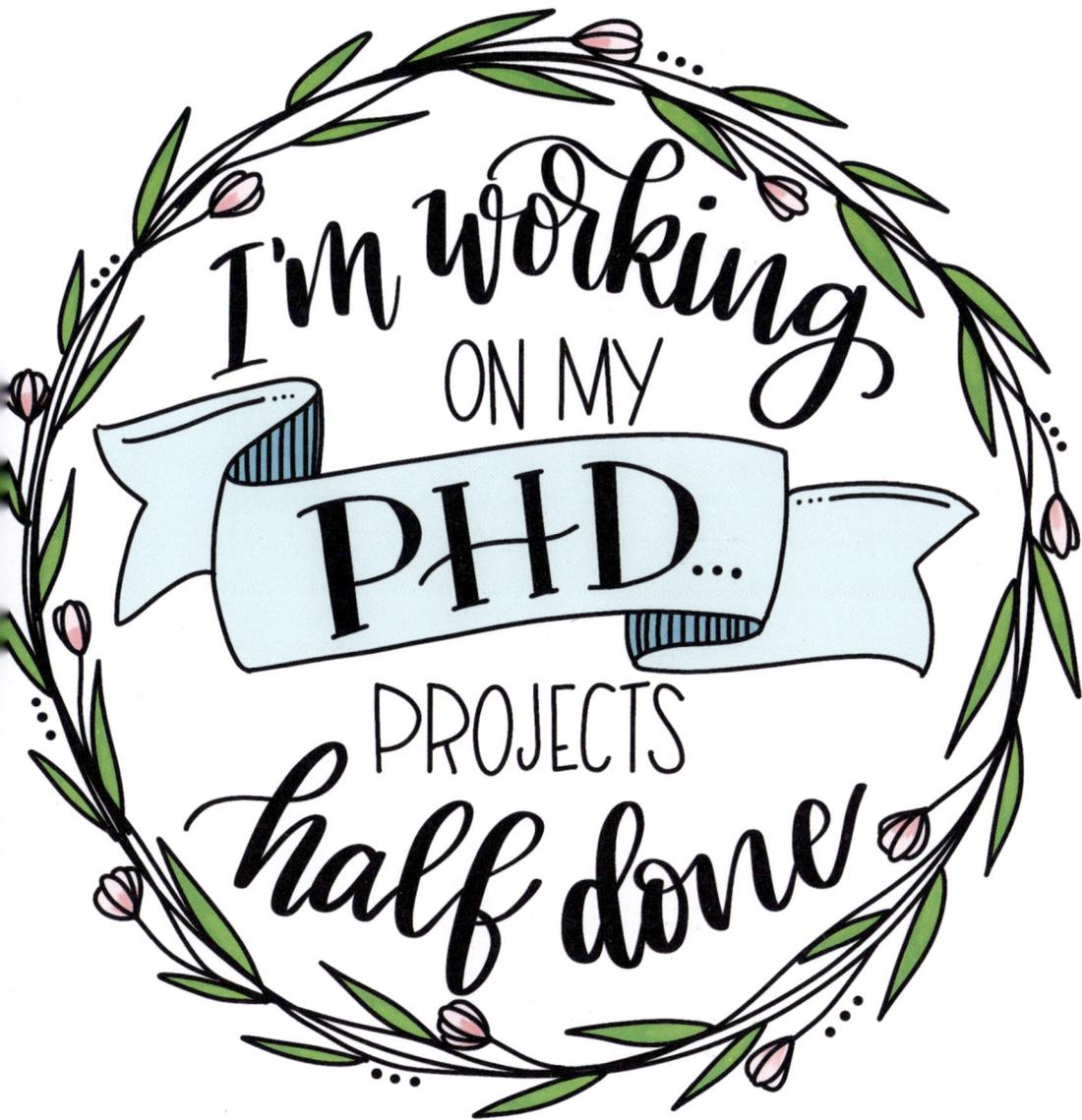

I'm working ON MY **PHD...** PROJECTS half done

Tackling Your "PHDs"

At first glance, my craft room is relatively organized. I have ample work space and an assortment of supplies for all kinds of creative endeavors. Just don't look behind the curtain in the back. If you do, you'll find an island of misfit projects—things I started with the best of intentions, then abandoned. Decorative pillows with no cases, half-painted flowerpots, partially stitched wall hangings . . . the one thing they all share is that they are incomplete. I'm willing to bet you have some of these, too, left in a drawer or closet somewhere and forgotten. Let's not let them defeat us! Let's tackle that pile of "PHDs" and show them who's boss! Some just need fresh eyes and new inspiration. Others may be better off disassembled so the pieces can be repurposed for something more exciting. Not every project turns out the way we imagined, but a finished project is better than an abandoned one any day. So, let's turn those "PHDs" into masterpieces!

Can you relate? What PHDs can you think of offhand?

Why Do I . . . ?

There are lots of reasons why we end up with unfinished projects. Take a look at the list below and circle the ones that resonate with you. Add any other reasons you can think of, too.

Time

Supplies

Skills

Difficulty

Distractions

Project Fails

Motivation

Energy

Inspiration

Money

Forgetfulness

Fear

My Biggest Roadblocks

Now that you've identified some of the reasons behind your unfinished projects, which ones do you think are your biggest stumbling blocks? Why? How do you think you could fight back against those obstacles?

My PHD Inventory

It's time to face them. Go to wherever you stash your half-finished projects and take inventory. In the space below, list five of the things you started but haven't completed, no matter what the reason.

1: _____

2: _____

3: _____

4: _____

5: _____

To Finish or Not to Finish . . .

Some of your projects may be just a few steps away from completion. Others may need a little TLC, while the rest might be best used as repurposed pieces or even thrown away. Sometimes we need to know what to let go of so that we have more time and space for the most important things. Take a look at your list and see which projects fall into each of these categories. Then, get four bins or boxes and physically sort your projects, so you know at a glance which ones are which.

ALMOST FINISHED	NEEDS TLC	BACK TO THE DRAWING BOARD	SAY GOODBYE

Operation: Completion

Choose one of your almost-finished projects and figure out what you'd need to do in order to make it complete. Do you need additional supplies? Does something need to be re-painted or re-done? Use the space on the next page to illustrate or write your game plan. Then, get busy and get it done! Once you accomplish that, don't stop. Use the momentum to go back to your chart and tackle another and another until your PHD pile is gone. Set a goal for yourself, perhaps a week's time, to revisit your bins and evaluate your progress.

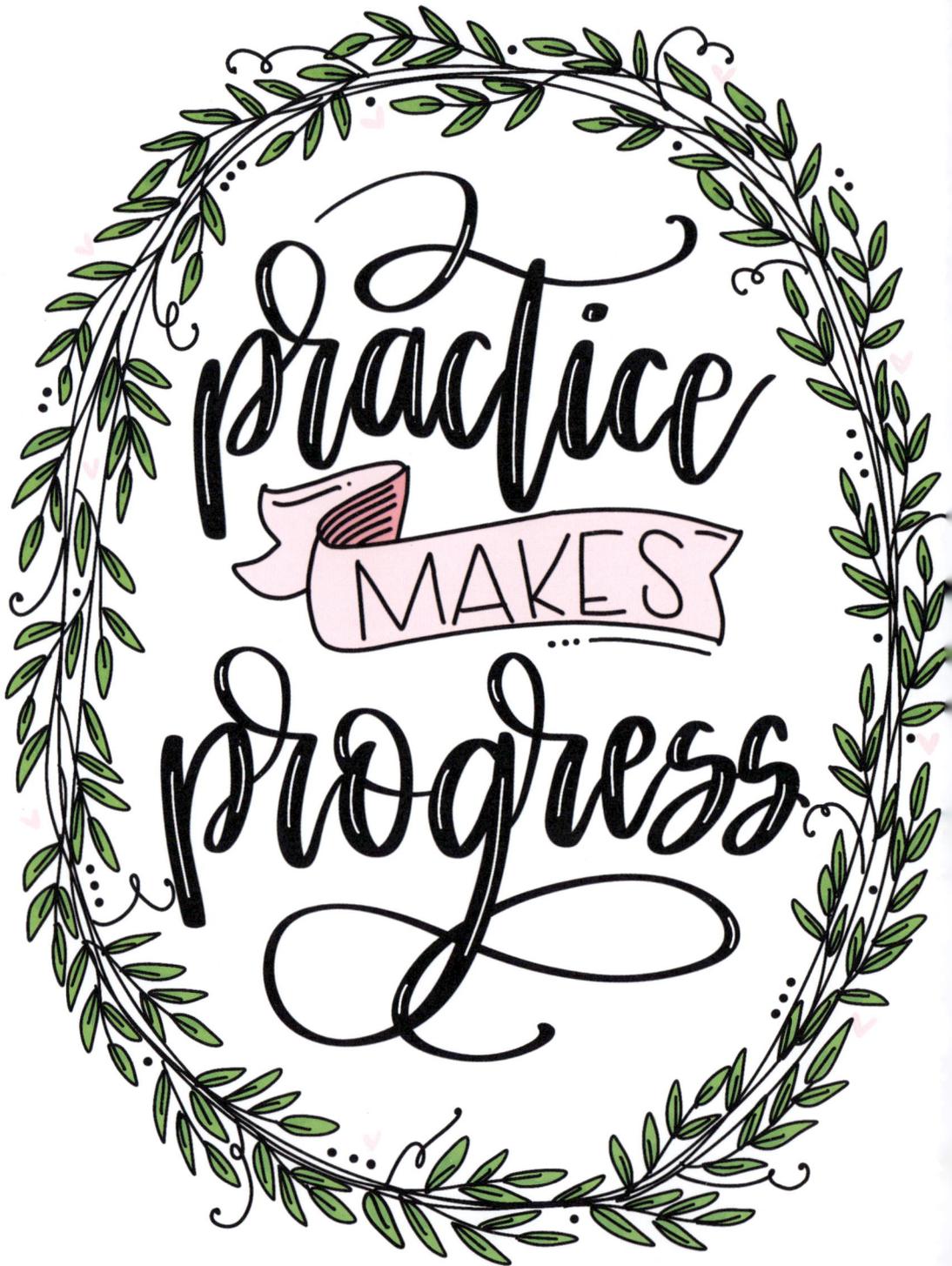

practice *makes* progress

Practice Makes Progress

I've had three very different careers since graduating college, but they've all involved teaching. Whether learning English, ballroom dance or hand lettering, students of all ages have come to me with the same complaint: "I can't do it as well as you can." My response? "I hope not, otherwise you should be teaching me." It's completely unrealistic to expect that your lettering will look professional the first time you pick up a brush pen or that your waltz will rival Fred Astaire's the first time you step onto the dance floor. Every skill requires practice if you want to improve. While there's no such thing as "practice makes perfect," it definitely does make progress. Each time you practice whichever creative skill you're learning, you'll find yourself a step closer to the result you want. It takes time and discipline, but there's no question that practice pays off. Stick with it, and you'll see that with time and practice, you can do great things. Do you prefer the idea that "practice makes progress" to the saying "practice makes perfect"? Why or why not?

Developing Muscle Memory

Believe it or not, the same muscle memory that allows us to ride a bike or drive a car without much thought can help us achieve greatness in our creative pursuits. The more we repeat the same action, the more naturally it will come. As an example, let's practice this in the form of hand lettering. First, trace the word below, writing over the black lines. Then, try to re-create it yourself in the blank space.

joy _____

Now, trace it twelve times in a row, writing over the black lines of each one. When you're finished, try writing it on your own again.

joy joy joy joy
joy joy joy joy
joy joy joy joy

Wasn't it easier to re-create that shape once your hand got used to making that same motion over and over? That's muscle memory at work!

Past Practice

What's something in your life that you have spent time practicing? For instance, a sport, an instrument or a speech. How did that practice pay off? How did you motivate yourself to keep practicing? Think about some practical ways to channel that same motivation into your creative pursuits today! Or, maybe your motivations now look completely different. As a child, you may have practiced something out of obligation or duty. Now, as an adult, what feelings or desires can you tap into that will help you see practice as a worthwhile pastime instead of a chore?

Preparing for Progress

What is one area of your creative journey where you'd like to improve your skills? First, set a goal on the line on the next page. Then, in the open space below your goal, brainstorm ways you could practice it. For example, if you want to improve your lettering, fill an entire page of a sketchbook writing nothing but the letter "a." Then, use the next page for the letter "b" and so on. If you want to work on your crochet skills, create a scarf made with nothing but a stitch you want to master. Repetition is the key!

my goal:

Keep It Consistent

Practice is most effective when we do it regularly. Any coach or instructor will tell you that daily repetition of your skills is one of the best ways to improve. Use the chart below to keep track of your progress this week. Each day you complete one of the practice activities you brainstormed, place a check mark or a sticker inside the daily box. Write down any notes you'd like as well. Then, at the end of the week, see how much your skill has improved with all that practice!

Sunday	
Monday	
Tuesday	
Wednesday	
Thursday	
Friday	
Saturday	

EVERY CHILD
is an
artist

THE PROBLEM IS HOW TO
REMAIN AN ARTIST
ONCE HE

grows up

PABLO PICASSO

Keeping That Childlike Wonder

Several years ago, when my son Noah was in elementary school, I got to be a long-term substitute for his art teacher. My favorite thing about that experience was seeing the absolute confidence with which the kids approached each project. They fully believed they were about to create something wonderful, and it was refreshing to watch. Why is it that somewhere along the way, our childlike joy gets replaced with responsibility and skepticism? What happens to the confidence that we can make anything with a pair of scissors, some glitter and a jar of paint? They know that art is not about perfection; it's about the fun of letting your imagination go wild. Isn't it time to let the child inside each of us capture that joy again?

Have you ever watched a child create something? What do you remember about that experience? If nothing is coming to mind, what are your memories about creating art when you were a child?

My Favorite Doodle

All of us had things we loved to draw when we were children. For me, it was a happy little house with a triangle roof and a big tree beside it, just like the tree in our backyard. There were always two fluffy clouds in the sky and the chimney always had a little curl of smoke, even though our real house didn't have a working fireplace.

What about you? What was your favorite thing to doodle? Think back, then draw that picture in the space below. If you can't remember a particular type of drawing, think of a treasured object, person or pet from your childhood that brought you joy and doodle that now.

Looking Back

How does it make you feel to draw that image again? Why? Do you see any traces of that early art in the things you create today? Use the space below to reflect on your thoughts.

An Artist's Toolbox

What were some of your favorite art supplies as a child? Circle them in the toolbox below. Feel free to add in words or pictures of any supplies you loved using that aren't included. You can also color in the toolbox and your favorite supplies!

What are your favorite supplies to use now? Write or draw them inside the empty toolbox.

A Tale of Two Toolboxes

How do the tools in your "childhood" box and your "today" box compare? What things have you consistently enjoyed using over the years? What new things have you picked up? Is there anything from your childhood that you miss working with? How does looking at the two boxes side by side make you feel?

Then and Now

Channel your inner child to create a nostalgic project in your favorite creative form. If you enjoy writing, perhaps you'll create a poem offering advice to your younger self or draft a story from a child's point of view. If you love the visual arts, paint, sketch, carve, stamp or embroider something memorable from your childhood. If you're a musician, compose or play a song that reminds you of your youth. These are just a few ideas to get you started. Whichever project you choose, feel free to use the space below to plan and begin your creative journey to the past.

Everything Is Art!

It's time to think outside the box and create like a kid again. Color and cut out the eyes and other facial features on the next page. Then, use adhesive dots or tape to attach them to everyday objects, turning them into silly creations! Add a face to an apple, give your piano some personality and make your lunchbox look back at you. For extra fun, snap a photo and share it to social media. Be sure to tag me at @amylattacreations and use the hashtag #MyCreativeJournal so we can all share in the joy of what you create!

JUST CALL ME the Little engine that said OKAY, but I need Coffee FIRST!

First Things First: Setting a Creative Tone

Some people love to wake up early. They jump out of bed and as soon as their feet hit the floor, they're ready to conquer the world. I am not one of those people. My husband and kids know that it's best not to approach me until I've had some quiet time alone and I'm properly caffeinated. All of us have certain things that help us to be more productive, and knowing what they are is a huge help when we're trying to create something. It's important to recognize how we can get ourselves in a frame of mind to accomplish our best work. Besides coffee, one of the things that helps me most is having designated spaces for all of my crafting supplies. Organizing my studio so that I know where everything is and keeping my workspace clean and clear are all vital to my level of productivity. When the room is a mess, I can't focus properly on what I want to do. What about you? What things help you get into a great creative mindset?

My Must-Haves

Circle the words below that help get you into your best creative frame of mind. Feel free to add other words that come to mind, too!

Coffee	Tea
Music	Silence
Outdoors/Nature	Indoors
Exercise/Movement	Relaxation
Organization	Chaos
Pencil & Eraser	Markers or Paint
Comfy chair	Desk
Other people	Just me
Early morning	Afternoon/Evening
Computer/Tablet	Paper/Book

47

The One Thing

As you can see, there are lots of things that go into making an ideal environment for creativity and self-expression, and they're different for each one of us. Of all the components you circled, what do you think is the one thing that's absolutely the most essential for you? What happens if you don't have it? Why is it so important?

Envisioning the Ideal

Using whichever materials you choose, create a representation of that one thing you find essential for your ideal work environment. Paint it, sculpt it, carve it, sketch it or make it into a collage. Write a poem about it or express it through a photo. If you're drawing, painting or writing, feel free to do so on the next page. If you're creating in a different medium, use the page as a place to plan and collect your ideas, then go make them come to life!

Make It Happen

Now that you've paused to really evaluate the most important components of your ideal workspace, it's time to make it a reality! Take some time right now, or at least schedule it on your calendar, to make some necessary changes. Maybe it's as simple as organizing your supplies and tidying up your work area. Perhaps it's a bigger task like finding or creating a space that can be just for you. Maybe you need to acquire a desk or create a playlist of music that will inspire you while you work. Take a minute to write down at least one specific goal to accomplish (including when you'll have it completed) that will make your workspace more ideal.

My Workspace goal(s)

Comparison is the thief of joy

THEODORE ROOSEVELT

The Comparison Game

There's a game we all play that no one ever wins. It's called the comparison game, and although we rarely intend to engage in it, it's so ingrained in our human nature that we fall into it without even trying. We look at another person and their creations, then make a snap judgment about how we measure up. We allow someone else's talent to be a threat to our own. Sometimes it can be discouraging to the point where we feel like giving up because we're afraid we'll never create something as impressive as the next person. When comparison and envy start to creep in, they rob us of all the joy that creating can bring. Instead of trying to outdo each other, what if we focused on celebrating the unique talents we all possess? We could learn from and be inspired by one another to create even greater things!

Is comparison a conscious part of your life or something that happens without you really thinking much about it?

Who's in the Game?

Who are some of the people to whom you tend to compare yourself? Are they people you know? Celebrities or professionals? Others who do the same type of creating you do? Or perhaps creators on social media? Take a minute to list some names in the left column of the chart below. We'll complete the rest of the chart in the next exercise.

From Competition to Inspiration

Rather than seeing these people as competition, let's focus on how their success and talent can help you in your own creative journey. Next to each name, write one thing that you can learn from that individual. It could be something related to your creative passion, or it could be the way they approach life or their hobby. For example, there's a hand lettering artist whose use of color I really admire and an artist whose large-scale projects inspire me to try bigger things. Another creative friend uses her crafting as a way to spread kindness in her community, which is absolutely awesome! Think about how the people on your list can become inspirations instead of competition and write those things in the right column of the chart on the previous page.

Quitting the Game

As a result of comparing ourselves to others, we end up with negative thoughts about our own abilities. It may be difficult, but I want you to write those thoughts on the next page. Get all of it out and in writing . . . all of the "not-good-enoughs" and the negative self-talk that is stealing your joy.

Now that you've gotten it all out of yourself, I want you to tear that page. Not just out of the book: tear it up into a million tiny pieces and throw it away. Remove those thoughts physically, visually and mentally, because they are untrue. Our negative self-talk is nothing more than lies we tell ourselves, based on messages we've heard from culture, social media or sometimes even the people in our lives. Not only are those things false, they don't define us or our worth. Next time you're tempted to play the comparison game, remember this moment and remind yourself not to entertain those lies anymore.

I can't... I'M NOT... I didn't... NO... I can't... I'M NOT... I didn't... I WON'T... NO... I didn't... I'M NOT... I WON'T... I can't... I'M NOT... I didn't... I WON'T... NO... I can't...

The Power of Positivity

Now that we've literally gotten rid of the lies and negative self-talk that come from comparing ourselves to others, let's focus on something more positive. It's time to replace those old lies with statements of truth. Choose one of the following statements or write one of your own; then turn it into a piece of artwork. You could hand letter the phrase, illustrate it or express it in any creative manner you like. Use the space on the next page for creating or planning.

My art has value. I have talent. I make the world more beautiful. My creations matter.

Unique You

Sometimes we spend so much time focusing on the ways we think we fall short that we forget about the things that make us unique. Each of us has a special combination of abilities, inspiration and passion that leads us to create things only we could make. What are some of the things that set you and your creations apart? In the space on the next page (or on a larger surface), create a collage that celebrates them! Hand letter or illustrate words, write a poem and/or use photos, artwork or other images to visually express the great things that make you a one-of-a-kind creator.

Creativity Is Messy

Whether you enjoy woodworking, painting, writing, quilting, baking, scrapbooking, metal stamping or any number of other creative pursuits, you know firsthand that the creative process is messy! Although I attempt to clean and organize my studio between projects, if you happen to walk in while I'm working, you may wonder if you stepped into a natural disaster zone. Paper scraps, wood shavings, glitter . . . none of these things want to be contained! I used to feel bad about it, but I've come to realize that the mess is simply part of the journey. It's no surprise that the area for creativity in the brain is a completely different section than the one for organization and logic. In order to create, we have to be willing to dive in and get our hands dirty . . . often literally! Don't be afraid to embrace the mess and even enjoy it, because it leads to awesome things.

Do you consider yourself a messy crafter or a neat one?

My Kind of Mess

The kind of creating you do will determine the kind of messes you make. Because one of my main art forms is hand lettering, my desk is often covered in eraser dust. I also paint many of my home décor projects, so it's not at all uncommon for me to find paint on my table, my clothes and even occasionally on the cat! Below, describe your own typical creative mess using words and/or pictures.

Messes Make Me . . .

From the time we're kids, most of us are taught to avoid making messes instead of embracing them. Especially for those who value organization and order, it can be tricky learning to enjoy the creative process when it explodes all over the room. What about you? How do messes make you feel? Are they a cause of stress or a source of joy? Why?

Managing the Mess

One way to find balance between a messy creative process and an organized space is to brainstorm tips for easy cleanup when your project is complete. For example, when I work with certain materials, I cover the table with a disposable plastic tablecloth. When I'm finished creating, I just roll it up, along with everything left on it, and throw it away! For other projects, I make sure to have a tote full of soapy water on hand so I can toss paintbrushes and other dirty tools in as I finish using them. Take a minute to brainstorm tips like these with your own hobbies in mind.

I can wear:_____

I can cover the work surface with:_____

I can put dirty tools:_____

I can put trash:_____

I can contain my work to (a cookie sheet, a tote, a box, etc.):_____

Other things that will make cleanup easier:_____

Let's Get Messy!

The next page is all yours: a place to make a mess and have fun in the process! Grab whichever supplies you have on hand . . . glitter, paint, markers, glue, ribbon, felt . . . anything goes. Then, use them to color in the border vine and create something in the blank space. It can be as abstract as you like; just let yourself play. Don't worry about making a mess—that's the whole idea. Have fun, let go of perfection and use this opportunity to find new creative freedom.

CREATIVITY

is

Contagious.
Pass it ON.

Albert Einstein

Pass It On

Creativity isn't something we're meant to store up and keep to ourselves. Instead, when we use it, we inspire those around us to do the same. One way to pass on our creativity is to share the things we make with others. Whether we gift our creations to the people in our lives or sell them to folks we've never met, sharing our work is a significant act. Another great method for helping others "catch" the creativity bug is teaching them how to do what we do. Years ago, a friend who knew how to make beaded jewelry came to my home with her supplies, sat me down and walked me through a few basic skills. It ignited something in me and since that day, I've made more pieces of jewelry than I can count; all because my friend took the time to share her knowledge. Teaching one-on-one, leading a small workshop, making an instructional video or doing large-scale classes are all wonderful methods for helping others unlock their own creative potential!

Have you ever thought of creativity as contagious? Do you agree with this idea?

Sharing Is Caring

What is an area of expertise you could share with others? What are you good at that someone else might enjoy? Think about some ways you could teach that knowledge. Is there a specific person who you could instruct? A group? Write about your ideas below.

Creativity on Display

One great way to share your gifts with others is to find ways to display your work. Of course, placing it throughout your home is fun for your family and friends who visit, but what are some ways you can put it out there on a larger scale? Is there a local arts center or coffeehouse where members of the community can submit creations for display? Could you post photos online to inspire those who aren't near you geographically? It can be scary taking this step and putting your work in the public eye, but it's such a wonderful way to inspire others! In the organizer on the next page, jot down some ideas for where and how you can share your creations.

#My Creative Journal

Now that you've come up with some ways to share your creativity, it's time to actively take a step! Choose something you have created and snap a photo of it. Now, head to your favorite social media platform and share it using the hashtag #MyCreativeJournal. Be sure to tag me at @amylattacreations so I can see it and maybe even help you share it more! Once you've shared, check out the hashtag and take a look at the incredible creations that other members of this community have put out into the world. Choose three or four (or twenty) favorites and go leave an encouraging comment on their posts, thanking them for being bold and sharing their contagious creativity!

FAMILY and FRIENDS

LOCALLY

LARGER COMMUNITY

ONLINE

The Gift of Art

On the next page, it's time to create something with the intent of giving it away! Draw, paint, write, hand letter or anything else you'd like. You can also feel free to create something off the page: crochet, sew, carve, sculpt, stamp, bead or do whatever you're inspired to do. The only rule is that you have to do it with someone else in mind. Then, take your creation and give it to them as a happy surprise! You could do this in person or by mailing it to them.

God

WOULDN'T HAVE
MADE ME THIS

Creative

IF HE WANTED ME TO

cook and

clean

To Craft or to Clean: Setting Your Priorities

More than once, my husband and kids have come home to find that I got so wrapped up in a project I completely lost track of time. It's easy to do! Have you ever forgotten to do something-like start dinner!-because you were in the middle of a creation? You're not alone. One of the hardest parts of being a creative person is learning to balance our responsibilities and passions. We can err on the side of neglecting important things, which is what I tend to do, or we can go in the opposite direction and be so responsible that we don't leave ourselves enough time to do what we love. Neither one is a good solution. Finding the balance between work and play can be tricky, but when we get it right, we will be much more fulfilled.

Do you feel like your life is currently well balanced? Why or why not?

Love It or Leave It

Use the chart below to help you divide the things that take up your time. Think about what you do in a typical day, then write those tasks in either the "love it" column or the "leave it" column. "Love it" is for things you're passionate about or at the very least don't mind doing. The "leave it" column is for things you have to do but don't enjoy at all. For me, that's where laundry would go, but my husband actually doesn't mind it!

love it leave it

Tipping The Balance

Now that you've filled out your chart, take a look at the lists you've made. Which list is longer? What takes up more of your day? In the space below, draw a simple balance scale, labeling one side of the scale "responsibilities" and the other "passions." Draw the middle bar so it tips the scale to indicate which one is heavier (or shows a healthy balance) based on your "love it or leave it" chart. Color the drawing and write or doodle things in the scales to represent what's on your lists.

The Art of Delegation

One thing that can help free up some time and balance your day is to really consider the items on the "leave it" list and determine two important things. First, does this task truly need to be done? If not, let it go! If it really does need to get done, the second question is, does it need to be done by you? There are lots of ways to delegate some of our least favorite responsibilities. You could reassess the division of labor in your home, trading tasks with someone else or giving older kids more responsibility. Below, fill in the left side of the chart with your three least favorite responsibilities. Assess whether each one is essential, then if so, write an option for how you could delegate that task.

TASK essential? DELEGATE TO...

Making the Best of It

Despite our best efforts, it's inevitable that we will still be left with a few tasks we don't really enjoy, but that we still need to do. Instead of dreading it, try to make the best of it! Like it or not, someone has to make dinner every night, and although I hate cooking, it just doesn't work in our schedule for my husband to take on that responsibility during the week. But I do find that when I try a new recipe instead of making the same old thing, or when I get one of my sons involved in cooking with me, I enjoy it a whole lot more. Chores can be more fun if we blast our favorite music while we do them, or if we can find a way to turn them into quality time spent with someone else. When I manage to turn cleaning into a game, even my kids don't hate to play along. What are some ways you can turn your "must do" responsibilities into ways to find joy, gratitude or fulfillment?

Finding Your Balance

Finding the perfect balance between responsibility and passion isn't something that happens in an instant. It's also something that may change and evolve over time. It's a process, but it's one that's worth the effort. Use your favorite creative medium to create a piece of artwork expressing the need for balance in life. It could be a painting, a poem, a short story, a song, a wood carving, a hand-lettered quote or anything else you love to make. Feel free to use the space on the next page for planning and/or creating.

IT IS NOT *necessary* FOR AN *artist* TO BE **crazy** BUT IT HELPS

Using Your Right Brain

Scientific studies prove that not all of our brains are wired in the same way. For those of us who tend to be naturally creative and artistic, the right side of the brain is typically dominant. Those who are more analytical and logical usually depend more on the left side of the brain. Neither is right or wrong; it's just part of what makes us who we are. understanding how brain dominance affects us can help us to be more successful. For example, right-brained folks make excellent authors, teachers, directors, musicians and architects, but most are not cut out to be accountants. Not that they couldn't; they just wouldn't thrive. Both sides of the brain have their strengths and weaknesses. Recognizing those things in ourselves and figuring out how they influence us can help us to reach our full creative potential.

Is there someone in your life who you think is definitely right-brain dominant? How about left?

Righty or Lefty?

In the image of the brain below, circle the words that you feel describe you. Then, when you're finished, add up how many circled words you have on each side and see if your left or right brain is dominant!

ANALYTICAL
DECISIVE
STRATEGIC
MATHEMATICAL
LOGICAL
SEQUENTIAL
PRACTICAL
SCIENTIFIC
FACTUAL

creative
imaginative
intuitive
spontaneous
passionate
visual
emotional
artistic
imaginative

The Good, The Bad and The Ugly

Based on your discoveries in the previous exercise, what are three strengths that come with having the brain dominance that describes you? What is one weakness? If you struggle to come up with these, do a little research on more qualities of the right and left sides of the brain! It's fascinating stuff.

strengths

weakness

We Will Overcome

How might you overcome the weakness you identified? Is it something that comes with practice? Encouragement from a friend? Taking a class? What kind of action can you take to turn that weakness into a strength instead?

My Beautiful Brain

Using your favorite form of creative expression, make a representation of your right-brain or left-brain dominance. It could be a mixed-media collage, a sketch, a poem or story, a sculpture, a quilt square or anything else you like. You can use images, words, music notes or whichever tools you like to express the way your mind works. Feel free to create your art on the next page, or use it as a place to plan and then jump into your project.

AN artist

IS AN

EXPLORER

henri matisse

Artists Are Explorers

Creativity takes countless forms. Once you pursue one of them, it's almost inevitable to begin exploring more. No one can be an expert in every single type of creative expression, but it's fun to expand your horizons and try new outlets from time to time. In fact, exploring other art forms may just lead you to something you're even more passionate about! That's what hand lettering was like for me. I already enjoyed painting, sewing, writing and other artistic hobbies, but when I began learning the art of lettering, I didn't want to stop! Instead, I wanted to learn infinitely more and to letter on every surface I could find! Now, four years later, it's still my favorite form of artistic expression. If I had never given it a try because I thought it was too hard or I was too busy, I'd be missing out on something that brings me so much joy! Exploring new creative avenues may lead to some dead ends, but it can also lead to wonderful things you'll enjoy for years to come.

Do you consider yourself a naturally adventurous person? Why or why not?

Yes, No, Maybe So

Take a look at the list below, which represents many different creative pursuits. Use one color of marker to circle or highlight the ones you have tried. Take another color and indicate the ones you would be interested in trying at least once. Feel free to add other activities you think of, too!

drawing, sculpting, making jewelry, embroidery, sewing, quilting, woodworking, furniture building, interior design, hand lettering, ceramics, playing an instrument, wood burning, carving, making wreaths, furniture painting/upcycling, watercolors, sketching, graphic design, beading, macramé, crochet, knitting, baking, cooking, gardening, collage, mixed media, painting, quilling, cross-stitch, singing, makeup artistry, pottery, card making, rubber stamping, metal stamping, soap making, candle making, mosaics, photography . . .

Making a Plan

It's one thing to talk about trying something new, but another thing entirely to put yourself out there and actually do it! Choose one of the things you circled that you'd like to tackle first and write it on the line below.

Now, let's talk about your next steps. There are lots of ways to learn a new hobby. Watching a video, reading a book, taking a class or learning one-on-one from someone who has the skill are all great options. Take a few minutes to write some notes and ideas below.

Videos:_____

Books:_____

Blog Posts/Tutorials:_____

In-Person Classes:_____

Virtual/Online Classes:_____

People I know who are skilled in this area:_____

Now, choose one of these resources as your starting point and make it happen! Sign up for that class, call your talented friend or look for that online video right now!

Creativity Time

Once you have read that book, taken that class or watched that video, it's time to dive in and try out that new skill. Don't worry about perfection; you're trying something new, so give yourself plenty of grace. It doesn't matter how hard the process is or what the result looks like; the goal is simply to be an explorer and try out something you've never done before. If your skill is something that can be done on paper, like lettering, painting, drawing, writing a poem, etc., feel free to use the next page as a place for your creative work. If not, you can do your planning there, then use it as a springboard for working with other types of materials.

Thoughts from an Explorer

Now that you've taken the leap and explored a new creative avenue, what do you think? Reflect on your experience in the space below. How did it feel going out of your usual artistic comfort zone? What did you learn? What are you proud of about your project? Is this new skill something you will attempt again? Why or why not?

WE DON'T MAKE
mistakes,
WE JUST HAVE
happy
accidents
BOB ROSS

Happy Accidents

I don't think it's possible to watch and listen to Bob Ross without being inspired. His calm voice, his talent and his firm belief that anyone can paint are a powerful combination. But one of the things I appreciate most is his attitude toward mistakes. We are all human, which means mistakes are inevitable. It's what we do with them that counts. Many of us (especially perfectionists like me) tend to freak out at the thought of messing up. In fact, the fear of making a mistake can even keep us from taking risks. But what if we looked at mistakes the way Bob Ross did, as happy accidents? Instead of deciding that our work is ruined because we did something wrong, what if we looked at it as an opportunity to go in a different direction? What if we found a way to turn our error into something even better than what we originally meant to create? Personally, I'd prefer to try and see a mistake as something that becomes an opportunity rather than a failure. What about you?

Have you ever watched Bob Ross paint? If so, how did it make you feel? (If not, look up one of his videos on YouTube!)

Rose-Colored Glasses

The way we view our mistakes is often a reflection of our overall outlook on life. If we are perfectionists who tend to look for problems, we're sure to find them. If, on the other hand, we are optimists who can view our art through rose-colored glasses, it will be easier to overlook or adjust any imperfections we see. What color glasses do you think you use when looking at your own creative work? In the illustration below, draw, color and/or write words that describe your outlook when you evaluate something you made.

My Mistakes

Some forms of art make it very easy to correct mistakes. For example, if you make an error when crocheting or knitting, a gentle tug on the yarn will unravel it. When you draw or letter in a digital app, there's an "undo" button that will return you to the step before the mistake occurred. Other kinds of creativity, though, are less forgiving. When performing live, a misstep in the dance or a wrong note played can't be taken back; you just have to accept it and move on with the rest of the piece. Think about your favorite way(s) to create. Are errors easy to fix, impossible to undo or somewhere in the middle? What do you usually do when a mistake happens? What tools are required to correct or change it? Write or draw about your process in the space below.

Happy Accidents

In spite of what we might think, a mistake can actually help us take our work in a new direction. Recently, I accidentally put my hand in something I had lettered with paint marker before it had dried. It left a smudge on the surface, but rather than writing it off as ruined, I decided to turn the smudge into an embellishment. I added dots and stars around my words that wouldn't have been there otherwise, and they really added to the finished effect. Can you think of a time when a mistake changed your work for the better? What did you do? What was the finished project like? If not, how do you think viewing mistakes as an opportunity for growth could change the way you create?

A Daily Reminder

All of us could use a daily reminder that mistakes are a part of life, and they don't have to be negative! In true Bob Ross fashion, we are going to create a piece of art that reminds us to embrace the errors. Using any media you like, your challenge is to combine this "happy accidents" quote with some "happy little trees," a signature favorite of Bob Ross himself. You can hand letter, sketch, draw, paint, embroider, quilt, carve, wood burn or do any number of things to create your reminder. Use the next page as a place to do either your creating or your planning. Once your masterpiece is complete, display it or keep your journal open to that page on your desk or nightstand as a reminder that happy accidents happen and can be beautiful.

SUCCESS

USUALLY COMES
TO THOSE WHO ARE

too busy

TO BE

LOOKING FOR IT

Henry David Thoreau

The Definition of Success

unfortunately, in our society, artists and creatives are often made to feel like we have to get "real jobs" to pay the bills and pursue our passions on the side, if at all. Plenty of talented people have walked away from their crafts in an attempt to build what society tells us are successful careers. The reality, though, is that success takes many forms. Bringing more beauty to the world, inspiring someone else, creating something that didn't exist before . . . how can we say that these are not accomplishments? Allowing ourselves to fully invest in our passions and create for the sake of doing what we love can bring far more satisfaction than the endless pursuit of "success." And we may just find that our definition of succeeding changes along the way.

Do you agree with Thoreau? Why or why not?

What the World Says

Has someone in your life (or maybe even yourself?) discouraged you from pursuing your creative passions? Have you ever chosen to pursue the "sensible option" over something you really desired to do? How did that experience affect you?

Success Defined

Where have you gotten your ideas of what success should look like? Has it come from society? Books or movies? Your parents, friends or teachers? What have you been told are the key factors of being a success? Do you think these things are true?

My Kind of Success

Now that we've explored what you've been told, what does success actually mean to you? Put aside the expectations and definitions of others and focus on what you truly believe. Here are some ideas to get you started. Use them, along with your own ideas, to help you formulate a definition of what success looks like in your life. Then, write your definition on the lines below.

money, fame, an award, a particular accomplishment, personal satisfaction, a steady income, staying true to yourself, using your skills, promotions, being your own boss, independence, a degree, a job title, recognition in your field, a number of "followers," a feeling of pride, developing confidence, mastering a new skill, finishing a project

Make It Personal

Now that you've constructed a general definition for success, it's time to get personal and figure out what that actually looks like applied to your life. In whichever way you love to create, make a representation of what personal success is/would be for you. If you're a writer, turn "SUCCESS" into an acrostic poem with specific examples. If you draw or paint, make a picture of what success looks like to you. You can also cut out photos or magazine images and words to make a collage! Use the next page to create or brainstorm a creation off the page.

Make a Plan

Hopefully, after completing these exercises, you have a clearer picture of what success means to you and what it would tangibly look like in your life. Now it's time to make a game plan. Choose one of the things you incorporated into your creative project and write it on the line below.

What are three steps you could take, starting today, that would help this to become a reality?

1._____

2._____

3._____

Success doesn't have to look the same for all of us; these steps should be things that get you closer to what you envisioned in your personal collage, poem or drawing. Don't worry if it doesn't seem logical . . . the best dreams never are.

do

SOMETHING

creative

every Day

Create Something Every Day

There are days when I wake up recharged, inspired and ready to tackle whatever comes my way. Other days, I'm lucky to get out of bed and function like a semi-normal individual. But no matter how I'm feeling, I find that my day is more complete if I make the time to create something. Even if it's small, even if it doesn't turn out perfectly, even if it flat-out stinks, it's so important to do. It's not about the product as much as it's about the process. Creating is good for the mind and for the soul. Engaging in it every day is incredibly beneficial, whether we're feeling especially inspired or not. It keeps our minds and imaginations active. Doing something creative every day should become as much a part of our routine as brushing our teeth . . . and it's way more fun. So what are you waiting for?

How do you feel when you read this chapter's quote? Excited? Motivated? Overwhelmed? Why?

Every Day?

Think back over the past few days. Did you do at least one creative thing? Remember, all kinds of things count as creativity, including trying a new recipe, making up a dance to a new favorite song, doodling on a napkin and so much more. And of course, the exercises you do in this journal totally count! Write down at least one creative thing you did each day in the space below. If there's a day where you can't think of anything, no worries, but remember that even the smallest outside-the-box kind of activities can be forms of creative expression!

M	
T	
W	
Th	
F	
Sa	
Su	

C is for Create

Let's use the word "create" to do just that! Use the letters of the word to make an acronym about what creating means to you or your own creative journey. You can write words or phrases, hand letter them, illustrate them or cut out and paste pictures. Feel free to use my template below or to make your own from scratch!

C _____

r _____

e _____

a _____

t _____

e _____

Creating on Purpose

Do you have a daily time set aside in your schedule for being creative? Or is creativity something you try to fit in when you get the chance? If you are already purposely creating every day, how has that affected you? If not, how could you be more intentional about making and keeping that dedicated time for your hobbies?

A Daily Reminder

Use your skills to create a tangible reminder for yourself to create something every day. Paint the message on a rock you can set on your desk or carry in your pocket. Hand letter it on a pencil holder or a sign to keep on your desk. Embroider it on a pillow or stamp it on a piece of metal jewelry. However you do it, imprint that message somewhere you will see it daily so it can remind you to make time for creativity! You can use the words of the quote, "Do something creative every day," or simply focus on the word "create." I'd love to see how you created your reminder! Share it on social media with the hashtag #MyCreativeJournal or email me a pic at amylattacreations@gmail.com.

Even if It Stinks

It's easy to get caught up in focusing on the final product when we're making something. I mean, after all, we want something great that we can enjoy. But it's important to give ourselves permission sometimes just to create for the sake of creating! Whether the end result is wonderful or terrible, it's about getting our hands dirty and just letting our imagination go wild. On the next page, just for fun, draw something that stinks . . . literally! It could be a poop emoji, a smelly food, a toilet or anything else that will remind you that everything you create doesn't have to be perfectly beautiful. In fact, you can even take things a step further and doodle with your non-dominant hand, just to make sure your project isn't going to turn out perfectly! Let it stink-on purpose!

the earth
WITHOUT
art
IS JUST
"eh"

DEMETRI MARTIN

Making the World More Beautiful

Over the years, my husband has said countless kind things to me, but my favorite is when he told me, "You make my world a more beautiful place." He then went on to name some of the creative projects I've done in our home and for our family that he particularly enjoys. I can't tell you what those words meant to me. And if no one has said them to you yet, friend, let me be the one to tell you. You make the world a more beautiful place. It's true. By engaging in the art of creating, no matter what form it takes, you are a bringer of beauty. You are giving this world something it desperately needs. Art revitalizes us, it inspires us, it touches our hearts. Without it, where would we be? In case you've never been told, your creations matter. They keep the earth from being "eh" and make it a better place.

Who in your life has told you, either verbally or through their actions, that your creations make a difference?

Art Around Me

Take a moment right now to look at your surroundings. How is art, whether yours or someone else's, playing a role in making them more beautiful? From where I sit, I can see several pieces of furniture I've painted, wall art I created, books I've written and a flowerpot I decorated. I can also see photographs of my sweet boys, a painting and a wreath. I hear music being performed on my Pandora station, and I feel the comfort of a blanket and a throw pillow. There is beauty all around me, some of which I created and many things that were created by others. What about you? What do you notice around you? What do those things mean to you?

Not Just "Eh"

To illustrate the truth of the quote, we're going to do some word art! Below, I've written the word "EARTH" with "art" in a different font. Grab your markers and turn it into just that-art! Color, decorate and draw on and around the letters in any way you like as a reminder that art brings beauty to this world.

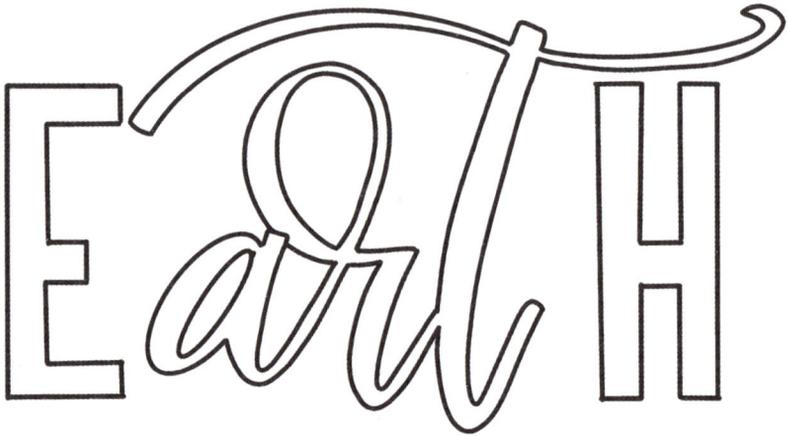

Imagine If

Take a moment to close your eyes and imagine what the earth would literally look, sound and feel like if there truly were no art. What would we see? What would we hear? How would we feel? Describe this "eh" earth by writing a description or a poem, composing a song, sketching an image or using any other creative media you like. Use the space below to write or draw or to plan a project.

Beauty on Purpose

Often, when I create, I make something without knowing exactly where I'm going to put it. Sometimes, though, it's fun to create with a specific place in mind. Think about your home, your neighborhood, your workplace and the other places around you. What's a spot that could use a creative touch? What could you make that would add beauty to it? Write or sketch a plan below, then get busy!

Spread the Word

All of us who create need encouragement sometimes. Who else in your life needs to hear that they make the world a more beautiful place? Use the next page to write a note or hand letter a message that will let someone know how much their art matters. Then, cut out the page with scissors, pop it in an envelope and mail it today!

IN EVERY
work of art,
THE
artist
HIMSELF
IS PRESENT

Christian Morgenstern

Leaving Your Mark

One of the things that makes our creations so interesting and unique is that they reflect who we are. It's what makes handmade pieces so much more beautiful than things that are produced on a factory assembly line. Every story has traces of its author, every photo shows us the perspective of the photographer, every song takes us into the mind of its composer. When we make something, we infuse it with who we are, usually without even realizing it. It's no wonder, then, that handmade gifts are so meaningful and original works of art are priceless treasures. My grandfather was a skilled woodworker, and when I was born, he made me a wooden cradle. Although he passed away when I was in college, anytime I run my hands over the smooth surface of the wood and close my eyes, I can imagine him in his workshop, painstakingly sanding it down and smiling, thinking about me. That is a gift indeed.

While you are creating, do you ever think about how the project reflects who you are? Or does it happen without you knowing?

What Do They See?

Each creation your hands have touched reveals traces of you. In a way, everything you make is a kind of self-portrait. Think about the last project you made. If someone who didn't know you were to observe it, what would it tell them about you, the artist? What would they learn about you?

Your Unique Thumbprint

Just as each of us has a thumbprint unlike anyone else's in the world, the things we create are totally unique to us, too. Let's have some fun using our actual thumbprints to create a one-of-a-kind piece of art! Grab a stamp pad or some acrylic paint in any color and press your thumb right into it. Then, press it down on the next page to start creating! Make anything you envision. You could use glitter, googly eyes and markers to turn your thumbprints into cute little creatures or combine a bunch of prints to make a mosaic-style image. Make a colorful abstract image, a pattern of prints or anything else you can imagine.

Portrait of an Artist

Although all of our work contains clues about who we are, there's something special about creating an intentional self-portrait. We can learn so much about an artist by looking at this kind of work; just think about the self-portraits of people like van Gogh, Picasso, Kahlo, Matisse and da Vinci. They are treasures, giving us glimpses not just of what the artists physically looked like but also how they viewed themselves. Your challenge today is to begin creating your own self-portrait. It can be as realistic or as abstract as you like; the goal is just to make a representation of yourself. You can paint it, sketch it, photograph it, sculpt it, carve it, embroider it, sew it or use any other media you like. Use the space below to plan it out, thinking about what colors, styles and elements you want to include. Then, grab your supplies and get creating!

The Gift of Yourself

Giving handmade creations is a way to give of ourselves, putting our time, effort and love into the act of creating. This kind of present is a treasure, irreplaceable and worth more than money. Think about one such gift you have received. What was it? Who gave it to you? For what occasion? Now, create your own form of a "thank you" to let that person know how much it meant, whether it was recent or many years ago. You could write and mail a simple note, or perhaps you'd like to create something to give back to that person. If you find yourself in a situation where you are unable to deliver that thank you to the original giver, make it anyway and consider giving it away to someone else (maybe even a friend or family member of that person whose gift meant so much to you). Feel free to use the next page either as a place to create or to plan your project.

TO **try & fail** IS AT LEAST TO **Learn.** TO **fail to try** IS TO SUFFER THE LOSS OF WHAT **MIGHT Have BeeN.**

BeNjamin FRaNkliN

Overcoming Fears and Failures

Failure is something most of us try to avoid at all costs. It's unpleasant and painful. The problem, though, is that while attempting to avoid failure, we can miss out on great things, like learning a new skill, sharing our work or even taking the leap to start selling what we create. Despite how it feels, failure isn't really the enemy; in fact, it can be a great teacher. When we try something and fail, we can learn from it, pick ourselves up and move forward. When we never try, we never know. How many incredible opportunities might we miss if we let those fears keep us stuck where we are comfortable? How many amazing things will never be created? I don't know about you, but I would rather fail at something I do and learn from the attempt than fail to try at all.

Do you agree with Benjamin Franklin? Does his quote resonate with you and your experience?

Success, Guaranteed

What is something that you would love to do if you were guaranteed success? If somehow you knew that you absolutely could not fail, what is the dream you'd chase? For me, it was finding a way to make money by pursuing my creative passions. It wasn't easy, and I did fail at several ventures before finding something that worked. If I had let my fear of failure keep me from making the effort, I would be stuck in a job I didn't enjoy instead of making a living doing what I love and being my own boss. We all have different dreams; what is yours? Take some time and write or illustrate in the space below what you would pursue if you were sure to succeed.

The Reality of Failure

The interesting thing about being afraid to fail is that we often don't stop to think about what failure would actually look like. We think, "I can't do that," and walk away without ever considering what the worst-case result would actually be. When I wanted to pursue my creative business, I would have been disappointed to fail, but it wouldn't have been the end of the world. The worst thing to happen would have just been continuing to do what I had been doing before. Or, when I tried and miserably failed at traditional wood burning, the worst end result was a messed-up scrap of wood and a little frustration. Nothing exploded and no one was the worse for my attempts. Think about the things that you are hesitant to try and ask yourself, "What's the worst that could happen?"

the risk ⤳ worst-case scenario

Weighing The Risk

Now that you've considered the worst-case scenario for the things you haven't yet tried, let's flip the coin and think on the bright side. What are the possible benefits if you succeed? They could be tangible, like money or physical creations, as well as intangible things like happiness. Fill out the chart below with the best-case scenario for each of your examples. Then, compare them to the things you wrote in the previous exercise. What do you think? Do the possibilities of success outweigh the fear of failure?

the risk ⤳ possible benefits

Try, Try Again

Sometimes we all need a reminder to pick ourselves up and try. Your creative challenge for this chapter is to make an artistic representation of the word "TRY." You can hand letter it, paint it, embroider it, create an acrostic poem, write it with fondant, burn it into wood or do anything else your heart desires. Use the space on the next page either for your creation or for planning your masterpiece.

BEING *Creative* IS NOT A HOBBY, *it is a* **way** OF *life*

Creativity Is a Way Of Life

There is a huge variety of hobbies that a person can pursue. Hobbies are pleasurable ways to pass time. Often, creativity gets described this way, as a hobby, but the truth is that it's so much more. It really is a way of life! I don't know about you, but when I see a blank surface, my mind immediately starts thinking about what I could do to make it beautiful. Some people see ingredients and imagine how they could combine to make amazing dishes or hear a few notes and imagine a melody. Being creative goes far beyond just doing something fun to pass the time. It makes us imagine things that don't yet exist, and it pushes us to leave things better than we found them. Hobbies can be picked up and put back down, but creativity is a mindset we carry everywhere. Sure, some of our favorite hobbies can be crafty, artistic, musical and so on, but creativity itself is a lifestyle, an integral part of who we are. Do you see creativity as a defining aspect of your identity? Why or why not?

Pleasant Pursuits

What are some of the hobbies you enjoy most? They can be artistic/creative, athletic, literary, technological, edible or anything else you like to do. Write or draw them in the bordered space below.

A Creative Life

Now that you've identified some of your favorite hobbies, we're going to look at how many of them are actually a part of your creative lifestyle. I have a few hobbies that fall outside the creative realm, like playing golf with my boys, reading and watching football, but the vast majority of what I enjoy is creative in nature. In addition to art and many types of crafting, I like to sing, play several instruments, write, decorate my home and ballroom dance. All of these are ways I express creativity. Let's find out how many of your hobbies are creative ones. Go back to the list you made in the previous exercise and circle all of the hobbies that are in some way artistic or creative. Then, come back here and fill out the chart below to see how your pastimes line up.

creative

academic

athletic

other

Creativity All Around

If someone who didn't know you came into your home and looked around, how and where would they see the evidence that creativity is your lifestyle? What things about your life make it obvious to an observer? What would these things tell them about who you are?

Hobbies as Art

Now, it's time to combine one of your hobbies with your creativity and make a special masterpiece. Choose one of the hobbies you listed before that doesn't necessarily fall into the artistic category . . . for me, maybe it would be golfing! Then, combine it with your favorite form of creative expression to make something awesome. For example, I could create a beaded stroke counter, make a ball marker, sculpt a golf club or paint the view from the tee box. It can be useful or decorative; there are no rules, just make something that represents a hobby you enjoy.

never,
NEVER,
never
GIVE UP

Winston Churchill

Never Give Up

One of the most important lessons I've learned is that great things are rarely achieved without perseverance. When I first set out to write a hand lettering book six years ago, I had won a contest that gave me guaranteed access to an editor at a large publishing company. To my delight, it passed through the first few steps of the process. In fact, it got all the way to the final decision maker . . . who then squashed it. I was sorely tempted to walk away from the whole idea, but my husband encouraged me to keep trying. He told me to find a publisher who saw value in what I had to offer, because my book was worth writing. I picked myself up and took his advice. I found a company that saw potential in my pitch, and together we created my first book. Then, we created more books, including the one in your hands right now. I'm so grateful I didn't let someone else's "no" become the final word. Whatever creative dreams you are entertaining, what you have to offer is worth fighting for. Do you naturally persevere or are you inclined to give up when the going gets tough?

The Power of Persistence

Some things in life can't be attained without persistence. Can you think of a time when this was true in your life? What did you learn from that experience? Did it affect how you approach other things? Did it have an impact on how much you appreciate what you achieved?

Given Up

Is there something you have given up on because you failed to reach your goal? For me, until recently, it was wood burning. I tried multiple times and always ended up failing miserably . . . until I found a new tool, the Scorch Marker. Now I am creating wood burned designs on everything in sight! All it took was a different approach. What is the thing you have given up or set aside because you haven't been successful at it yet? Draw or write it below.

Try, Try Again

It's time to take that thing you identified in the previous exercise and try again. Don't let failure have the last word! It's time to persevere and make your goal a reality. Maybe you need a new tool or a new approach like I did. Maybe you need to take a class, talk to a mentor or adjust your goal based on your previous experience. Take a few minutes to identify at least three specific, measurable action steps you can take to make a new attempt. For me, after being rejected by the first publisher, my three action steps were:

1. Fine-tune my book pitch.
2. Research contact information for publishers in the craft book niche.
3. Reach out to those contacts with well-written emails.

What are yours?

1 _____

2 _____

3 _____

Success Story

Now that you have a few specific action steps, it's time to get moving. The longer you sit and stop trying, the easier it is to give something up for good. But, if you're taking real, measurable action, you'll achieve your goals in no time. Be persistent. Don't be afraid. It's time to implement those action steps. Start with the first one and make it happen! Whatever it is, just do it. Use the space on the next page to track when you take the steps and what happens as a result. Feel free to create your own chart, schedule or organizer if that will help you to measure your progress.

I WANT TO make Beautiful things EVEN IF nobody cares.

— Saul Bass

Create Even if Nobody Cares

Every time we create, we are putting something new out into the world. Whether it's a song, a story, a piece of art or a delectable dessert, once it's created, it's almost always going to get some kind of reaction from others. As an artist, it can be tempting to focus on that reaction and get caught up in what everyone else will think about our creations. But at the end of the day, that's never the most important thing. What matters is that we are using our inspiration and making something, even if no one else cares. It's about self-expression and our own creative journey. There will always be critics who don't like what we do or say we are wasting our time, but that's okay, because we aren't doing it for them. We are making things because it brings us joy. That, in itself, is enough.

Do you relate to this statement from Saul Bass when you are creating? Why or why not?

I Just Want To . . .

What are your motivations for creating? It's fine (and very normal) to have more than one. Perhaps you create for self-expression, happiness or relaxation. Maybe your hobby is also a business and you create to earn an income. Do you make things as a way to share with or inspire others? Or does creating pass the time and give you an escape from reality? These are just some of the reasons why people create. What are yours? What motivates you to make what you do?

Where's Your Focus?

When you create, how much do you think about how others will react to what you're making? Perhaps you are a blogger or a shop owner and the opinions of an audience have an impact on your livelihood. Maybe, on the flip side, you are very private and don't share your work with anyone outside of a few trusted friends. Take some time to reflect on how important others' opinions about your work are to you. Write down your thoughts below. You can write a paragraph, a poem, a list or whatever works best for you to sort through your answer.

Who's Who?

Who are the people who experience your creations? How important are each of their thoughts to you? In the space below, write down the names of specific people or groups who typically get to see/hear/taste the things you create. For example, I'd write the names of my husband and kids, my parents and my best friends, as well as groups like my blog readers, TV audience, book readers, etc. Then, go back and number them in order of most important to least important in terms of how much you are affected by their feedback. Don't forget to include yourself on the list!

Who's Who

○ _____

○ _____

○ _____

○ _____

○ _____

○ _____

○ _____

○ _____

○ _____

○ _____

Just for Me

When is the last time you created something that was purely for yourself and for the joy you found in the act of creating it? Due to the nature of my job, most of my projects get shared on a large scale, but every now and then I make a personal project that's for no one but me. It doesn't matter how it turns out, because no one else will see it. This allows me to experiment and try new tools and techniques without worrying about what anyone else would say. Today, I want you to give yourself permission to do the same. Use the next page as a blank canvas to do anything you want. Hand letter, draw, paint or brainstorm an off-page project in your favorite style. It doesn't have to be fancy; it's just for you. Let yourself play and simply enjoy the process without worrying about the result.

THE DESIRE TO *create* IS ONE OF THE *deepest yearnings* OF THE *human soul*

PIETER UCHTDORF

The Natural Desire to Create

There is something deep and almost inexplicable about the human urge to create. As we look back through history, we can find countless examples of creativity in a vast array of forms—from cave paintings and the pyramids to modern art and architecture. Personally, I believe that it's part of how we're designed. I believe that we are made by God who is a creator Himself, and He made us in His own image. Creativity is written in our DNA, and although it gets expressed in a huge variety of ways, it's something we all have in common. When we create, we're connecting with one another and with a basic reality about who we are, and that is a powerful thing indeed.

Do you agree with Uchtdorf? Do you think creativity is a deep longing of the soul? Why or why not?

Ancient History

Besides the examples I listed before, what are some of the ways we see the basic creative drive of people throughout history? What examples have other cultures and civilizations left behind to prove that creating was part of their lives? Think about the history of your favorite forms of crafting. How did they develop and change over time? Draw some examples or write out your thoughts.

Soul Deep

When you create, do you feel as though you are satisfying your soul? Is it a feeling that goes beyond just a surface-level happiness? Are there particular projects you've done or certain types of self-expression that seem to satisfy you at a deeper level than others?

Doing What Comes Naturally

If creativity is written into our souls, it's as much a part of us as breathing, eating and sleeping. That means it should feel natural, not forced or difficult. In fact, it may be so natural that sometimes we hardly even recognize it. Some of the things I do without even thinking are perceived as incredibly creative by others in my life. For example, the way I arrange flowers in a vase, coordinate my outfit, organize my markers or doodle a grocery list. What are some of the things you do naturally that are really expressions of creativity? Think about the way you arrange your home, the way you cook, the way you dress, etc. Write some of those things in the leaves on the next page. Then, the next time you do them, take a minute to appreciate that it's a way your creativity is expressing itself.

My Creative DNA

Creativity is not only something we are born with; I think some of our particular creative inclinations are passed down to us. As you think about your own "creative DNA," go back through your family tree and think about how your parents, grandparents and other family members expressed their creativity. I had a great-grandmother who was an incredibly gifted pianist, a grandmother who was a seamstress and a grandfather who was a skilled carpenter. My other grandmother taught me to crochet and is the best cook I know. What about you? For this exercise, your challenge is to make a representation of your family tree showing the creative outlets that are part of your heritage. You can draw it, sculpt it, paint it, stamp it, quilt it, embroider it, write a poem about it or anything else you like. Use the next page to brainstorm and plan or as a surface for illustrating your project.

CRAFTING

fills my life

{ AND MY CLOSETS
AND MY DRAWERS
AND MY TABLE }

Crafting Fills My Life

About ten years ago, we were living in a small townhouse. I didn't have a dedicated craft room, so my art supplies really got out of control. I was creating projects on the dining room table, then trying to clear them off in time for dinner. I remember one evening we were having tacos, and as I looked into one of the topping bowls, I saw not just cheese, but glitter. That was the end of working on the dining room table. Most of us who embrace artistic hobbies can identify with the idea of our supplies taking over. It can get really overwhelming, both for us as creators and for the people who live with us. That's why it's so crucial to put some kind of organization system in place. The more you can identify where each type of tool and supply belongs, the easier it will be to find your supplies and to clean up when you're finished with a project. Getting control of your materials isn't always fun, but it's a necessary step toward being more productive . . . and to not finding glitter in your cheese.

What's the funniest crafting mishap you've ever had?

Crafting Fills My . . .

Where has your creative hobby spilled into the different areas of your home? Take a minute to think about all the places where you store (or accidentally leave) your various crafting tools and supplies. Then, circle them on the list below. Feel free to add any areas I forgot!

Living Room

Bedroom

Basement

Garage

Bathroom

Kitchen

Pantry

Office

Family Room

Guest Room

Laundry Room

Attic

Dining Room

Hall Closet

Other Closets

A Place for Everything

Even if you don't have a dedicated room just for your hobby, it's helpful to have one specific place where you keep your supplies so that they're all together. What spot in your home makes the most sense for holding your creative materials? Think about your options, then jot down the best one on the line below. If you already have a place where you store all, or most, of your supplies, then write it here.

Creating a System

Once you've identified the best place to store your supplies, it's time to think about an organizational system. Do you already have a system started or will you start over from scratch? I suggest separating your supplies by type. Then, separate even further, like splitting paintbrushes into large, medium, small. Finally, sketch out a plan for how and where you will store these containers. Here's an example of how I have my supplies organized. I know not everyone has the same space available, but hopefully, it will give you some ideas. Use the space on the top of the next page for brainstorming and creating your sketch. Visualizing an organized space is the first step to having one!

glitter

Mod Podge

My Books!

scrap
afbet

a

paints

paints

washi
tape
&
Ribbon

Jewelry

Jewelry

Paints

glitter

pencils

markers

pens

metal
stamping

Iron On

Vinyl

Vinyl

paints

paints

paint

vinyl

Mod Podge

Mod Podge

Cricut Infusible
Inks

stencils

Kid Crafts

fabric
paint

Foil

Tape

Glue

Glue Guns

Heat Tools

Felt

pens & markers

glue

scissors

Cricut

Maker

Metal Stamping Supplies

easy press

mat

Joy

case

paint brushes

Just Joy

Thread

Specialty

Paper

Cricut Pens

Joy

Joy

Joy

Mats

Blanks

cards

chalk
Paints

Infusible Ink

wood stamps

Cricut
mats

3-2-1, Organize!

Now that you've visualized a plan, it's time to get to work. Physically gather all of your supplies into one area and start the sorting and storing process. It will take some time and effort, but the payoff will be worth it in the long run. You'll be so much more productive and your home or studio will feel like a more peaceful place. Take out your calendar and set a goal for the date when you'd like to have this organization project complete. Write that date on the line below to hold yourself accountable. Now, make it happen!

Before and After

Once you've completed the organization process, take some time to think about where you are now compared to where you started. Was the process easy or difficult for you? How do you feel now that you have a new system in place? How do you think this will impact your daily life and your creative pursuits?

I LIKE

LONG, ROMANTIC

walks

DOWN EVERY AISLE

AT THE

craft store

Showing Love to Creatives

According to counselor and author Gary Chapman, each of us has a primary "love language," a way in which we best communicate and receive love. Some people thrive on affirmation and compliments, while others feel especially loved when they receive gifts. Still others need quality time, physical affection or acts of service. No matter which of these is our primary language, though, I think every creator would agree that we feel incredibly loved when someone supports our passion. There are many ways to support an artist. For example, there are times when my husband offers to take me to the craft store just to browse. Even better, sometimes he entertains our boys so I can wander the aisles all by myself! When my kids show off things I've made to their friends or when someone I know wants to purchase my books, it speaks loudly and clearly about how they feel. What are some of the ways the people in your life show love by encouraging your creative passions?

Feeling the Love

Think about a time when someone you care about did or said something to encourage your creative pursuits. Who was the person? What did they do? How did it make you feel? What impact has that experience had on your creative journey? Write about your experience below.

Love List

There are countless ways to support a creative person. In the hearts below, brainstorm some practical things that would mean a lot to you. For example: buy my art, give me supplies, share my work/shop online, listen to me talk about my latest project. . . . Write your ideas inside the hearts.

Share the Love

Now that you've had a chance to reflect on how much it meant when someone supported your creative endeavors, it's time to return the favor by doing the same thing for someone else. Think of a crafty/artistic/musical friend who could use some encouragement. Choose one of the things you brainstormed in the previous exercise and do it for that person. In the space below, write the name of the person and the specific thing you are going to do. Then, go make it happen!

I will share love with _____

by _____

That Loving Feeling

How did it feel to step out and do something to encourage a fellow creative? How did that person respond to your actions? Use the space on the next page to reflect on the experience you had in the previous exercise. You could write a poem, illustrate the person's reaction, create abstract art or anything else you'd like to do.

the artist *is not a* special kind of person; RATHER each person *is a* special kind of artist.

ANANDA COOMARASWAMY

A Special Kind of Artist

When many people hear the word "artist," they have a very specific idea in mind. Maybe it's a person with a canvas and a palette, or with a particular skill set, like digital design. More often than not, though, most people see it as something apart from themselves. In reality, each of us is an artist in our own way. Take my father for example. He will be the first to tell you that he can't draw more than a stick figure, but he spent his career building with brick and stone. Yes, some of what he built was functional, but some of it was also highly artistic. Fireplaces, decorative walls, even sidewalks . . . it takes precision and a trained eye to make beauty from blocks. He doesn't see that in his own way, he is as much of an artist as he considers me to be. You are, too. Whatever you create, that is your own form of art. You are an artist. Let that sink in and let yourself own it. You are a special kind of artist. Where did your definition of "artist" come from? Who taught or told you what an artist is?

Idea of an Artist

When you hear the word "artist," what comes to mind? Is it a specific person or people? An image of something? A particular set of skills? Use the space below to draw or write your first thoughts.

My Special Kind

Is it easy or difficult to think about yourself as an artist? Why is that? Write your reflections below. You can make a list, write a poem, write a paragraph or express yourself in any other way you like.

Encourage an Artist

This quote has such an important message for each one of us. To help it sink in, we're going to create an artistic piece that includes some or all of its words. You could hand letter the quote, create a mixed media collage, create it with metal stamps, embroider it, burn it into wood or paint it. There are no rules for how you create your project, other than that the goal is to incorporate the words, "Each of us is a special kind of artist." Use the space on the next page either as a surface for creating or as a place to plan what you'll make. Once your project is finished, you can keep it for yourself as a reminder or cut it out and gift it to one of the people you brainstormed in the previous exercise who might need to learn to see themselves as the artist they are.

Acknowledgments

Dear Reader–Without you, there would be no books, website, tutorials or workshops. You are the reason why I do what I do, and I am truly grateful for you.

Sarah–You are a dream to work with and I love the way we created the concept for this journal together. Please be my editor forever.

Charlotte–Thank you for helping me share my books with the world in so many exciting ways. Let's go tell everyone about this one!

Will, Meg P., Laura, Meg B. and the team at Page Street–Thank you for always believing in the next book and in me. You are the best publishing team in the business and I'm grateful to have you as mine.

Dan–Thank you for always being my #1 fan. It means more than you will ever know. I love you more today than yesterday.

(continued)

Acknowledgments (Continued)

Noah—I love to watch you explore and embrace your creativity. You are going to do great things, Little Crafter, and I can't wait to see them happen.

Nathan—You inspire me to be a better mama and person. I love you and I'm so glad you are my son.

Mom and Dad—Thank you for supporting everything I do and for helping me to believe I can achieve anything. I love you.

Erin—Thank you for keeping the day-to-day operations running at ALC so I have time to write. You're the mocha to my caramel.

Bill and Chrissy—You have my eternal gratitude for your helpful ideas and the grilled cheeses.

About the Author

Amy Latta is passionate about sharing honest inspiration for everyday life. On her award-winning blog, amylattacreations.com, you'll find easy-to-follow hand lettering tutorials, along with all kinds of craft and DIY projects anyone can create. She also loves teaching in-person and virtual workshops all across the United States through Michaels Community Classroom, Pinners Conference and other venues. Another of Amy's favorite avenues for sharing creative tips is doing segments on the lifestyle television shows Good Day PA, Midday Maryland, KSL's Studio 5 and Hallmark Home & Family. And, of course, you can learn from Amy by reading one or all of her five books on hand lettering, the most popular of which, *Hand Lettering for Relaxation*, has sold over 100,000 copies. Amy is happiest when crafting, and when she's not covered in paint, you can find her working on hand-lettered art and professional design collaborations. Her original lettered designs have been featured nationally in GAP stores and Starbucks commercials. Amy is a Maryland girl who runs on iced coffee and loves spending time with her husband, their two sons and their furry friends.

Congratulations on Completing This Journal!

This isn't really an ending, though. It's just one part of your creative journey. I hope that the exercises you've done on these pages will serve as springboards to help you jump into all kinds of exciting new things.

As you continue to explore and create, I would love to continue to share the journey with you. Anytime you make something new, feel free to post photos and tag me online at @amylattacreations.

You can also use and follow the hashtag #mycreativejournal so we can all inspire one another.

I can't wait to see what you create!